The publication of this book was generously made possible by Swiss Re.

Urs Stahel

Well,
What Is
Photography?

A lecture on photography on the occasion of the
10th anniversary of Fotomuseum Winterthur

Fotomuseum Winterthur Scalo

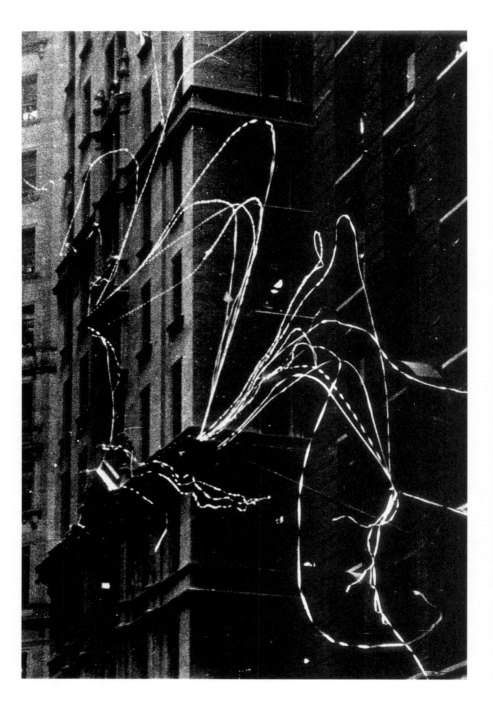

Well, What Is Photography?

A museum for photography. When we inaugurated Fotomuseum Winterthur on January 29, 1993, we were confronted with a variety of reactions. The first critical voices disapproved of calling the institution "Fotomuseum." They thought that it sounded outdated and old-fashioned and suggested a dusty place where you could mainly study various instruments, machines, and photographic procedures. Others, yearning for reassurance, asked whether we would show color photography, with an undertone suggesting that we certainly wouldn't, would we? This remark is reminiscent of the reaction that the 1976 exhibition by William Eggleston at the Museum of Modern Art, New York, provoked. It was met with violent rejection as color photography was deemed unfit for a museum because at the time it was mainly used in advertising.

We opened Fotomuseum Winterthur with the exhibition *New Europe* by Paul Graham. When a group of commercial and advertising photographers from Zurich visited the show, we had to worry about the photographs as they were so annoyed by them. They complained that they were not in focus and the colors were off, and hence the work as a whole, including any of its content, was rejected. And vice-versa we were often asked: "Why are you opening a Fotomuseum, when so many art museums have started to show photography?" Or that I should please shift the emphasis from realist long-term documentaries to concept-based photography. And: "Why didn't you open up a media museum?"

The expectations photography has to meet. This variety of reactions surprised us. They showed how disparate the expectations and the understanding of photography still were in the early 1990s. But the answer to the question "What is photography?" is actually quite simple at first sight.

Robert Frank, Ticker Tape, New York, 1951. On permanent loan from Volkart Foundation

Photography is a device to record light, invented in the 19th century (according to current research), that allows us to fix the perspective perception of the world in the manner construed since the Renaissance. Optics and chemistry go hand in hand to create a very efficient means of perception.

Despite the apparent simplicity of this first definition, there are very few comparable cases in which a seemingly clearly and easily delimited field – here's the viewer, there's the world; here's the instrument, there's the image of the world – has created so much confusion. Obviously there are many different concepts of photography, all of them presented with great emphasis. Without hesitation, people take a deep breath and announce in a booming voice: "This is photography!" "No, this is photography!" "This isn't photography anymore!" "You are wrong, this is photography!" The more forceful the claim, the more likely it is that someone is standing nearby ready to declare the same three words just as emphatically but with a different meaning in mind. But this proclamation, even today, can actually mean quite a number of things, containing hidden statements like, "This is photography because everything is in focus." "This is photography because it is perfectly printed and comes in the predetermined trade-mark colors – Kodak red or Fuji green." "This is photography because it shows narrative scenes from real life, easy to recognize and read." "This is photography because it is politically committed." "This is photography because it captures the world's beauty." "This is photography because it fits into the art world's current discourse." And so on. And all of these remarks encompass the exclusion of their opposite – the out-of-focus, the off colors, the naked or the clothed – in short, of everything that is not the one and only true and proper photography according to this particular personal view. The absolute character of these proclamations is evidence of their intention to determine at once what photography *is* and what it *should* be. The resolute tone of the exclusion, however, suggests that obviously quite a few things are at stake – things that may not immediately and exclusively be connected with photography.

This is photography! The claim "This is photography!" conceals the question "Well, what is photography?" The first answer, concise as it is, should

have precluded any misunderstandings. But whereas we are often in agreement with regard to general definitions – preambles of constitutions are a prime example – our opinions on their practical application often widely and irreconcilably diverge. Hence, I want to supplement this first concise definition of photography with several other definitions revolving around the existence and effects of this light-recording instrument:

Spatially speaking, photographs are little segments of the world, abstractions onto a plane surface, square or rectangular, construed according to the rules of one-eyed central perspective, which recorded in close-up does not correspond to our actual vision, but appears stunningly similar beyond a certain distance.

Temporally speaking, they are the fixed traces of the light and the shadow of a thing that was in front of the camera at a certain point in time, whether the photograph was taken somewhere out in the world or whether it was produced in a studio. The shutter clicks and the clock jumps to the past. The future is excluded from this medium.

Semiotically speaking, photographs are only slightly coded images. In contrast to language, which combines letters in complex structures with a comparatively exact meaning by means of rules – and yet, even in this field, misunderstandings are not the exception, but rather the rule, as we know – photography functions as a kind of subtraction from the world, which itself is an only slightly coded structure. Consequently, a photograph rarely comes alone. Not only reporters but also amateur and family photographers love series as the single photograph is similar to an obstinate, mute, enigmatic child.

Speaking in terms of the theory of perception and of epistemology, photographs function as a reinforcement of vision. In photography, we begin to retreat from the world. We orientate ourselves less towards the tactile, olfactory, audible and experiential world and more towards optical signals and visual data, sometimes without making a precise distinction whether our gaze is resting on immediate reality or on worlds mediated by images. When we are standing on the beach and comment on the sunset with the words, "This is almost as kitschy as a postcard," this is a good example of the confusion of our experiential worlds. We believe we are

coming closer to the world, and yet we are simultaneously withdrawing from it. Photography accompanies vision's triumphal march and helps to pave the way for abstractions of the concrete world.

And finally – *speaking in terms of world view* – photographs advance a positivist approach to the world. They are a visual confirmation of the turn to the worldly and the superficial. The world's surface is optically scanned and photographically examined in the belief that we can say something about that which is behind the surface by means of surface signs. We could call it "photographic research based on circumstantial evidence," alluding to the types of research based on circumstantial evidence that emerged parallel to photography during the 19th century: surface data are collected, combined and interpreted in order to discover truth in the sum of the single parts – of a painting in art history, of a crime in criminology, of the psyche in Freud, of the world in photography.

And finally, it is important to emphasize – *speaking in terms of media theory* – that photography not only documents events and incidents; it not only creatively represents them but actually engenders them. In a media-tized world, only what is "talked" about and displayed matters. Anything else does not exist; it is simply not there. Photography is creating the world that we want to and will remember by means of its images.

Photography as an instrument for showing things. Most of all, photography is probably an instrument for showing things, a device for displaying them. As soon as its principle was discovered and its technology invented, things were photographed in order to show them: photographs were taken abroad in order to show them at home, to present them to one's own social class. Right from the beginning, it encompassed a great degree of social distinction. The first photographs (in the 19th century) showed the world calmly and in its entirety, from an appropriate distance. The use of smaller cameras, of roll film, of flash lights (in the 20th century) disturbed this calm and violated the figure's intactness. Photography now "discovered" the

Paul Graham, Untitled #15, 1998. From "End of an Age." Gift Volkart Foundation

sunken and the hidden; it discovered the snapshot showing the unexpected: a beggar on the street, kissing lovers, a drop of milk on impact, a woman climbing stairs, a body revealing itself in contortions. New film stock, new telephoto lenses, electronic nightviewers soon disrupted the intimacy of film stars as well as the integrity of space (Hubble). Through electronic devices, public display arrives at an all-encompassing totality. Simultaneously, it becomes clearly obvious for the first time that the research and discovery of things and their relations, virtues nobly attributed to photography, are merely the lesser and duller side of the medal; its shiny side are revelation and public display: "Here, here, look at what I have to show you, what we have to offer you!" It was always like that. But, step by step, we have diminished the appropriate and "courteous" distance to the world and to the Other, down to a shameless and acerbic closeness that alienates us even from ourselves.

The history of photo, video and digital technology is just one aspect of this rapacious swirl from distance to closeness, of dragging the private into the public, of privatizing the public sphere. But it is the visible index of the increasingly pornographic nature of society. Yesterday, Stan and Ollie threw pies in each other's faces; today, close-up genitalia are smacking against the screens. None of the calm, integrity, and distance of the photographic gaze of the 19th century. The pornographic gaze transgresses all limits; it dissects everything in a fast, hectic movement, constantly exalting itself. The gesture of total revelation always and already offers an infinite abundance of signs and meanings, like a gigantic smorgasbord that is always here for us, morning, evening and night, constantly replenished and newly set. But it also means tiring redundancy.

Photography draws its representational power from its paradoxically dual nature. On the one hand, the realism of photographs is so convincing that they appear to be spatial and temporal facts, and we begin to believe that we can grasp the world through them. As if we were standing on a

William Eggleston, Woman Sitting on a Red Cushion, 1973

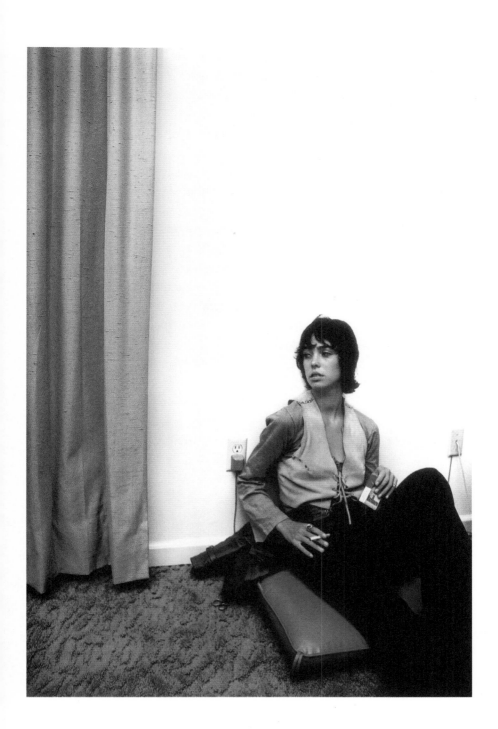

slightly elevated point of view, the position of a military strategist, where we can visually participate in the world without any immediate consequences, without actually having to be a part of it – out of reach and reaching out to it at one and the same time. We could speak of the colonization of the world by the photographic gaze because it makes us believe that we can know and own the world without ever having been in it. We become mere connoisseurs and traders of the images of the world. On the other hand, photography is open for any kind of projection on the viewer's part as it is only slightly coded and discontinuous, a mere segment taken out of the world's spatial and temporal continuity. It is a kind of mute tale that starts and stops, suggests and offers, only to fall silent again, leaving the results open. It is at once clear and opaque. This amalgamation of understanding and wondering – at once illustrative information and open visual field, testimony and surprise packet – adds up to an unusual power and endows photography with modern-day magical properties. This attractive and powerful combination of document and image is the source of many misunderstandings regarding photography. Research has repeatedly shown that ten people will give ten very different readings of one and the same photograph, in particular if it is a single image and has no caption, or if it is not part of a reportage, a narrative, or structured according to intelligible rules, i.e. partaking in a "legible" visual language.

And the question of photography's truth. As a photograph is always simultaneously an autonomous image as well as the representation of something, we are forced, time and again, to talk about the things it represents. Two things manifest themselves in a representation: the view of subject taking the photograph and the motif itself, the world in front of the lens. In the first case, I as another subject feel qualified to talk about it as we are all accustomed to look at the world. In the case of the latter, we are inevitably confronted with other fields of knowledge – about landscapes, cityscapes, urbanism, and urban organization for example. Talking about photography always forces us to talk about many different worlds. Consequently, it is a kind of destabilizing discourse with a generalizing claim.

I am actually pointing out a fundamental problem: the question of what photographic truth consists of, or what truth in photography is. I am talking about the perpetual confusion of "that it was" and "how it was." A traditional analogous photograph is the trace of an actual event. Something happened at a certain point in time in front of the camera. It was there, as Roland Barthes said. And this thing that was there caused an optical-chemical imprint that we can now look at in a photograph. A trace of Napoleon III is present in an old photograph of Napoleon III. Napoleon III was there (intentional forgeries excluded). This trace of time or of existence contains a truth, i.e. something happened, but is does not tell us – or only very imprecisely and with a bias, from a singular and furthermore one-eyed perspective – how, where, and in what context something happened. Photography talks about pure, almost meaningless factuality: that something was there, that something happened. This is in the nature of photography, the medium itself. Everything else is not the pure, almost automatic imprint of reality on film, but the result of the photographer's or the artist's relation to the world. It corresponds to the context he moved in. The image is expression of this relation, which is never neutral, never static, never complete, never democratic, never truthful in any absolute sense. It emerges from a dynamic, performative process, a larger spatial-temporal context, and from the construction of the world as an image world.

Industrial Photography: the Theater of Objectivity

After these general and generalizing remarks on photography, I will pick out three photographic fields and examine them more closely.

The photography we consider closest to reality we would qualify with terms like "documentary," "factual," "neutral," or "objective." Industrial photography belongs to this type of photography. Photographic training in a large industrial company used to be among the most interesting and most comprehensive kinds of schooling. An industrial photographer had to make portraits of workers and employees when they entered the company and when they left it upon retirement. He had to be able to photograph a simple little object so perfectly that it was possible to discern its material and how it was modeled. He had to accomplish the same on a larger scale when he photographed a cogwheel with a diameter of 12 to 14 meters. He turned into an architectural photographer when he had to photograph the gigantic factory buildings from inside and outside. He created little documentaries on factory inspections and staff outings. The industrial photographer registered and examined raw materials; he studied and rehearsed production procedures; he documented incoming goods and people; he assisted the patent division. He internally communicated in the company's staff bulletin and to the outside in "propaganda" brochures, familiarizing the public with new products or illustrating the achievements of the company. He showed its products as a kind of object that just fell from heaven, in front of a white background, removed from the production process. In most cases, he remained anonymous. He was just the staff photographer – whether he photographed at a micro, macro, or regular range. For a long time, he would always use a view camera. Earlier on, it used to be a 18 x 24 cm camera and later a smaller 13 x 18 cm camera on

Hans Danuser, Untitled, 1988. From "In Vivo," Portfolio VI 14. Gift George Reinhart

a tripod, which requires a calm and concentration reminiscent of the painter and his easel.

Whatever he might photograph, the industrial photographer had to follow certain very strict guidelines, probably much more so than in any other field of photography. The photographs had to be fine-grained. The light should modulate in a manner that would render tonal values evenly and comprehensibly. On the whole, the image should be in focus. And all objects should be represented without any distortion if possible. These four elements formed the credo of the industrial photographer. In order to fulfill it, he learnt everything about film stock. He used spotlights, mirrors and white paper to show the merchandise. Using Scheinpflug's law, he determined the position of the focal plane that would show the decisive parts in focus. When he was faced with inconvenient highlights – in factories there's always something gleaming or flashing – the metal parts were matted by various means. When he developed or, if necessary, copied a negative, he balanced it, toned it down, or intensified it only to later retouch it with a scraping knife or a soft pencil ("To retouch a negative with a pencil, mattoleïn, a solution of dammar resin in oil of turpentine, has to be rubbed onto the coating...") He retouched it until the desired brilliance, density and definition of bright as well as dark parts was achieved. If a machine had to be isolated, he applied red tempera paint directly onto the positive, first with a brush, later with an airbrush, to make insignificant parts appear diffuse, important parts crystal clear and immediate.

Consequently, we are facing a paradox: in order to arrive at the desired objectivity, i.e. a well-defined, sharp, undistorted representation appropriate to the material, every trick of the trade was used, including almost painterly means. The photograph was manipulated to create a neutral representation of an object. Industrial photography was not characterized by simple documentary records but by lavish visual constructs. Whether an object is photographed in front of a white background in the manner of a magical object-orientated realism, or whether a factory building, its shining machines and a few workers are arranged for a photograph, or whether we immerse ourselves in the photograph of an expansive space, or

whether it shows workers in a line welding as if they were on stage in a play called *Oxyacetylene Welding in Three-Four Time*: it was always staged, arranged, and finally shot after long preparations. The lack of light and the low sensitivity of film stock made it impossible to show all the men in focus at once. They had to stand there and start welding, and on "one-two-three" they had to hold their breath and stand still for two, three or four minutes. This was the only way to produce a photograph.

When you talk to an industrial photographer, young or old, he will immediately start to tell you a story and remember how complicated the shooting was, how many flashes he needed – "Yes, sixty of them, and on top of it I had to modify the wide-angle lens" – as if he were a mechanic, an engineer of images, and not a photographer. There is no talk about the aesthetics of an image or about its possible meanings. The photograph is not an aesthetic result but an event, a production, something staged. This attitude makes the industrial photographer a director, and the photograph becomes an "industrial still," a still life removed from the production process, similar to a film still.

The goal is always objectivity. It is also deeply engrained in the photographer's self-image. But gradually you notice how objectivity looses its apparent impartiality and becomes a kind of corporate identity for the entire industry. It is the self-image that industry wants to project. It corresponds perfectly with the fantasy of the technical, mechanical, precise, and clean character of industrial work. It avoids the sooty darkness of a foundry. The images always look brighter than the factory actually was. It eliminates dirt and sweat and partially manual labor itself: machines don't sweat. Industrial photography avoids any expressive moments as the production process should seem structured and efficient.

Now we have to ask ourselves whether there is anything true or authentic left in this staged objectivity. Or have we just unmasked objective industrial photography as mere pathetic effort, as propaganda, as pure advertising? We are looking at industrial photography as an example of the type of photography that creates a superbly realist illusion by virtue of its fine grain, thorough sharpness, perfect outlines, and rendition of hues. These photographs are almost perfect *trompe-l'oeils*, and they are

nurturing the illusion that they represent reality in a pure state, and that photography really is an open window. The "indexicality" of the image, its reference to reality, is so strongly emphasized that we forget to question the medium carrying the information or the point of view it represents. The "true-to-life" representation deceptively strikes us as real, an impression further fostered by the enduring predominance of empiricism and positivism. It entices us to reflect exclusively upon the relationship between the world and its image while concealing the relationship of the photographer to the world in the guise of gullible objectivity. In this respect, we have just exposed industrial photography. We are dis-enchanted by it. The industrial photograph is not a neutral document with a high representational source value. It is more of a concretization of social values, as David Nye and Allan Sekula have shown. Industrial photographs represent nothing more and nothing less.

Digression. Digitalization does not change anything about this situation. A digital image still talks about the author's relationship with the world. Only, the digital image makes this really obvious, and we are no longer able to deceive ourselves. The digital image is opening up our eyes to a 160-years old misunderstanding. The transformation is happening on our part. On the part of the object, we can no longer be certain that "it was there." The trace, the imprint of past reality is cut off from its referent as we are able to digitally intervene into and change the very structure of the image. Photography is loosing its untroubled relationship with time and world. The truth of the visible is being replaced by the construction of perception. End of digression.

The photographic quality of the fact that something was there in front of the camera reassures us of the self's and the world's existence. Photography today is no longer the radically new form that it was in the 19th century. It is no longer this new medium that allows us to contain the world in a form and to abolish or even burn matter as Oliver Wendel Holmes enthusiastically demanded in the 1850s. It is much rather the medium through which we believe to grasp the world, or even more radically, to grasp it for the last time: "Here, it's the world, look at it before it is gone, before it definitely disintegrates into obscure formulas and codes lacking

vividness and intelligibility." When photographs are now suddenly out-of-focus and no longer clearly and reliably represent reality, when they are digitized and manipulated instead, they loose their conservative character still so dear to us and their promise of emotional authenticity. They are no longer able to convince us that the world still exists. We loose one more ontological anchor in the security mechanism of contemporary existence – and we tend to take this rather badly. This may partially explain the resoluteness of the inclusions and exclusions I have described in the beginning. There is more at stake than just photography. Our self-confirmation and self-confidence are at stake.

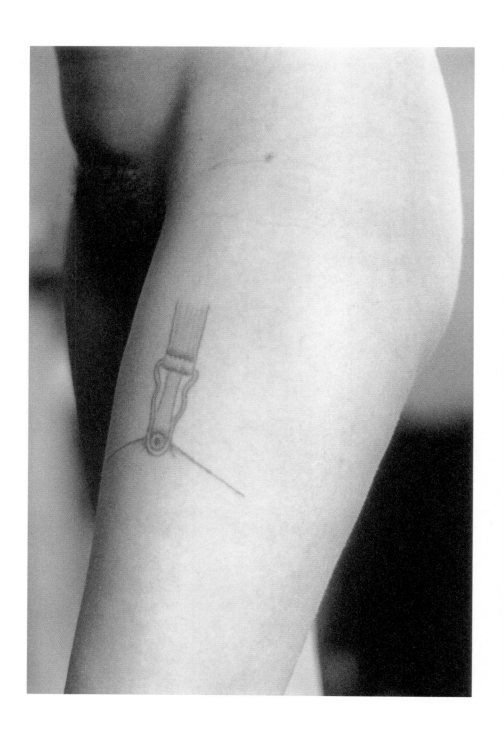

Playing with Images, Investigating with Images – Conceptual and Staged Photography

Similar behavior to that described above is generally becoming apparent in our dealings with images. The image was taken very seriously in the 20th century, and it presented itself with such force as if it were the true prospect of the world, a sacred law or plan allowing us to guide the world. You had the impression that the white canvas corresponded to exalted, pure, and absolute time; that the black canvas expressed empty and annulled time, sheer nothingness; that the red canvas was the equivalent of the vigorous, blood-drenched time of action. Abstract canvases, nevertheless highly charged with meaning. Attitudes and images were passionately serious, sometimes intimately and poetically serious, but also intellectually serious and serious in the face of the steaming sublime. Even the major visual heretics of the 20th century were not always immune to seriousness.

What does this mean? What does this sacred seriousness mean that had vanguard clash with vanguard? Vanguard clashing with vanguard always also means absoluteness clashing with absoluteness. Three statements that should make us think are at work here. First, the apparent seriousness and its absoluteness are actually in contradiction to the commandment, as is written in the second book of Moses, "Thou shalt not make unto thee any graven image, or any likeness of anything that is in heaven above, or that is in earth beneath, or that is in the water under the earth." (2. Moses, 20.4) The contradiction is not so much on the level of actual content, but in the attitude and the seriousness of image production and reception. They froze in front of the image as if they were facing a deity. The image was deemed absolute as if the image came from a beyond,

Valie Export, Tattoo, 1970/1998

placed into the world from outside and hence absolute. Second, the utopian claim, or even belief, implicit in the statement, "After this image the world will be different. Art has the power to change the world." And third, the events of the 20th century – the two world wars, Auschwitz, the atomic bomb – and the question of whether you could still write a poem in this world after Auschwitz and the atomic bomb (as Adorno once asked), and whether you could still search for any kind truth in language, sound, and image.

In any case, there was a considerable seriousness prompting two suspicions: did images turn into an important secondary battlefield and a necessary political fixation because of the historical catastrophes of the first half of the 20th century, which could not have been more devastating on a political, economic, and humanitarian level? Maybe it wasn't the image as such that was taken so seriously, but its function as refuge from and surrogate of the world? Was the image approached as a vicarious reality, understood and projected with the absolute seriousness of the "real," with the full force of utopian projection and in tune with the social pulse of the era? Was the image considered a secular commandment and a secularized icon in the first half of the 20th century, and is photography a self-confirmation in a fleeting time at the end of the 20th century? The suspicion suggests itself. It will have to be verified in detail as a question of the psychology and the reception of certain works.

This will to the absolute, this succession and collision of vanguards and their manifestos, found a surprisingly fast and abrupt end in the 1960s and 1970s. Artists of the 1960s and 1970s were still serious, but they assailed the sacred seriousness described above in very different ways. If there had still been manifestoes, they might have read like this, "Appearances are deceiving, and that's what we want to show. Style is finished. Thank God. Because now it's about the idea. The world is mutating, it's splitting up. Let's have a close look at what's happening." Some art became a serious game. As Beat Wyss wrote, "At the conclusion of modernism art learns to laugh again." For others it turns into an area of research, an instrument to investigate perception, the image, the self, the world. The aura, the sublime, the absolute was dissolved, removed, and questioned. With great laughter, the

sublimity of a light-flooded dome or a star-studded sky is exposed as a plastic colander backlit by neon, photographed on Polaroid film. The image and the dominance of form and style are at stake, and with them our perception, our seriousness, our search for the clearly outlined and properly framed way, our addiction to the formalized, remote work.

Since the beginning of the 1950s, with an emphasis in the 1960s and 1970s, perception and the image have been the object of an all-encompassing, enduring and serious investigation. On the one hand, vision and cognition were questioned and analyzed; on the other, the belief in the image and the reality of the image was challenged. In photography, it was the rejection of the single image, a shift to series and sequences of photographs. In painting, it was the explosion of the rectangle and the image's limits overflowing onto the wall, into space, and into life. In both cases, it is a demystification, a purification of meaning and sentimentality. From now on, carrier materials (frame, canvas, photo paper) and a surface (grounding, color coating, photographic emulsion) in combination with a couple of thoughts, ideas, experiments, and aspects are sufficient material for a work of art. Or the action replaces the result. An unfolding action becomes the focus of attention, dissolving and replacing the artwork.

Until the 1960s, photography had a clearly outlined mission. It was a visually reporting medium that brought the world abroad into our homes. As such it was always at our service and convincing on a practical level, but not particularly attractive for theoretical contemplation. With the exception of Walter Benjamin, Siegfried Kracauer, and Roland Barthes, only a few theorists up to then had dealt with the medium in detail. In the 1960s, however, photography underwent a major paradigmatic change rocking its self-understanding, and as we all know these are the situations in which we are most capable of reflecting ourselves.

The 1960s badgered photography in many respects. Photography lost its role as the first, only, and omnipotent visually reporting medium to television, in particular after the first portable video cameras became available in the late 1960s. This change cannot not be underestimated as from the first moment on TV would always be faster than photography, and it would always project a much more convincing appearance of being "real" and "up

close." Photography lost its function for the first time and was removed from its actual field of labor. Everything that has lost its function will sooner or later end up in a museum, or so our culture seems to wish. In the 1960s photography became a collector's item with a market value for the first time. Photo galleries opened up, and museums in Europe gradually began to take photography seriously.

At the same time, photography entered the field of art. First as a photographic sign of something real, for instance in Robert Rauschenberg's paintings and silkscreens. And then, with a slight delay, as an artifact and an art object in itself. And in a rather unanticipated manner: art presented itself as increasingly photographic, photo-real. Among others, it abandoned utopias for the sake of recording and commenting on the world and its relations. It gave up totality as a creative goal for the sake of playing with fragments. It started to photographically investigate the world as a world of signs. It photographically examined perception in time and space. It photographically appropriated and decontextualized found imagery from the media world and played with the countless fragments of a dissolved performative self.

In other words, we are in the midst of the conceptual turn in art and photography. John Szarkowski, then curator of the photography department at the Museum of Modern Art in New York, wrote in an article entitled "Another Kind of Art" in the New York Times in 1975 that contemporary artists who at least nominally started out as painters and later worked in non-pictorial art forms (happenings, concept art, land art, systems art) quickly demonstrated an appreciation of photography as a technology to document the ways of human experience. He emphasized that these photographers learned from Duchamp and Tinguely that the act of art does not necessarily require manual dexterity, and that a photograph could be an artwork without obviously being a beautiful object.
There is something slightly disdainful about this statement for Szarkowski was one of the last great modernists and loved the perfect print. Never-

Hans-Peter Feldmann, from the portfolio "The Little Seagull Book," 1975

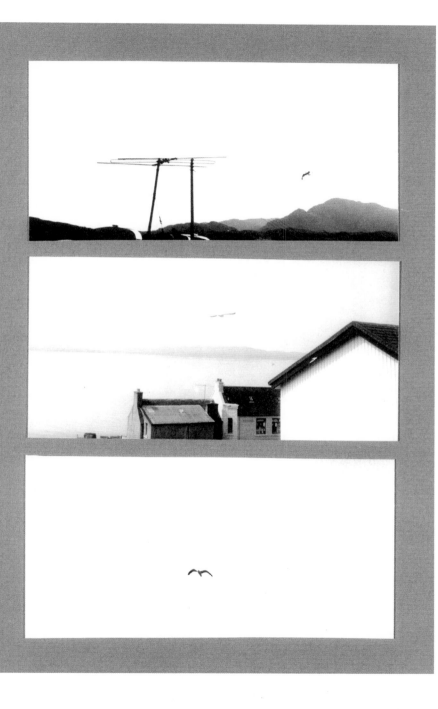

theless, he describes the transformation perfectly well. The conceptual artist loves the concept and not the object. He focuses on visual thinking and not on the fabrication of an exclusive object. The idea of the image and not the actual visual artifact matters. And photography is used like a language as the carrier of a cultural message.

Sol LeWitt wrote in his paragraphs on conceptual art: "In conceptual art the idea or the concept are the most important aspect of the work. When an artist uses a conceptual form of art, it means that all of the planning and decisions are made beforehand and the execution is a merely perfunctory affair. The idea becomes a machine that makes art. This kind of art is not theoretical or illustrative of theories. It is intuitive, it is involved with all kinds of mental processes and it is purposeless. It is usually free from the dependence on the skill of the artist as a craftsman." Now, what does this mean from the perspective of photography? From the perspective of those photographers who until then were trained to follow the rules of modern photography, of New Objectivity and of straight photography, the rules of Albert Renger-Patzsch or Hans Finsler in German-speaking countries or of Alfred Stieglitz in the USA? These were photographers who focused on justifying the photographic based on photography itself, its optics and its chemistry: straight photography, no cropping after shooting, a regular, balanced progression of hues from black to white, no accentuation by means of lab work, a direct view onto the world, visually and photographically well crafted and printed. This canon, which was still valid, even sacrosanct, in the 1960s, was facing the biggest challenge in the history of photography, entailing numerous transgressions of rules: a lack of appreciation for the single image, which was increasingly replaced by a serial and sequential arrangement of photographs; sloppy prints, the first prints on plastic paper, copies of newspaper imagery; brittle photographs; cropped and pasted photographs; actual montages and assemblages; a conspicuous absence of tonal values in color photography, etc.

The photograph was not appreciated as an exciting singular event, but as a sign with certain givens and rules, a sign that was questioned and used to examine our perception. All of these changes could be summed up under the title of an exhibition at Museum Folkwang, Essen, in 1980:

Renouncing the Single Image (Absage an das Einzelbild). It expresses the conviction that the single image can only say very little as it is only slightly coded. On the contrary, you need sequences, series, blocks, and arrangements of photographs because only they can engender a visual language, narrative, and analysis. Simultaneously, the auratic and emblematic aspects of photography and the emotional and moral weightiness of the 1950s were renounced. In the course of this development, photography was purified (of sentimentality). Hence, it became more "present" and was set in the context of an increasingly media-dominated world. In step with the general conceptualization of art, photography backed away from the auratic object and from modernity's canon – towards more realism in its engagement with the world; towards art as a medium of research; towards ideas and reflection as central elements of the artist's work.

Digression. This development took a surprising turn in the 1980s. On the one hand, it became more radical. In the 1980s, everything was a sign. A veritable semiotics boom dominated the decade. Everything could be read as a sign referring back to other signs. Everything – work, love, and the world – was a text in the fashion of French philosophy and could as such relate to every other text. Semiotics became increasingly absolute: signs only referred to other signs. There were only signs and no more referents. The most radical type of semiotics even claimed that representation and language could no longer say anything about reality, merely about the codes by which the world is perceived and determined. End of digression.

This gave a new freedom to photographers. If there was nothing conclusively real, then you no longer have to photograph it. You might as well stage images in the studio. They would be a statement with an equal claim to truth or truthfulness. Staged photography turned into the big boom of the second half of the 1980s. Staged photography (or table-top photography, as it is called in the applied arts) with its total control of the image referred both to painting and the painter in total control of the image, and to the sculptor or installation artist in control of his installations. "Equilibrium is most beautiful before it collapses," as Fischli / Weiss stated in the subtitle of their work *Stiller Nachmittag (Quiet Afternoon)*, in which they enthusiastically and playfully presented fruits, vegetables, kitchen uten-

sils, shoes, and rubber tires arranged in a delicate equilibrium. Their subtitle points out an essential feature of staged photography: it is staged just for the duration of shooting. Staged photography also refers to film and advertising, on which it modeled itself. If the photograph is a sign, respectively the combination of different signs, a maximum control of its sign character is desirable. Film, Hollywood film in particular, makes no dogmatic claim to truth. It adheres to the laws of genre and aspires to the perfection of production. It stages unreality, and with a smile it gives up Western art's claim to truth and authenticity.

Countless staged photographs flooding the art world in the second half of the 1980s aspired to these cinematic qualities: photography as the photograph of an installation; photography as the successor of premodernist figurative painting; photography as a still from an imaginary film; photography as narrative, almost like an illustration in a children's book; photography as the play of the different levels of media. It was no longer an interpretation of reality. The actual construction of visual realities was the order of the day. The fixation on the real that modernism had established as photography's nature was gone. Instead, worlds were being built up and staged in the studio in order to photograph them. Visual fragments of the outside world were now used as mere raw materials and subsequently reworked in the darkroom. The claim to originality shifted from the creation of photographic images of the world to the composition of a tableau of already existing private or mass-produced visual material. Fictional illusionary worlds were built up in front of the camera like in a movie studio or in the theater – still lives as postmodern allegories, narrative tableaus, in which once disdained narrative and fabulist elements resurfaced.

This new freedom also had its downside. The art world jumped on staged photography because it offered a way out of abstraction and could be looked at through traditional art historical criteria. In this respect, it remained obliged to a concept of art determined by conservative values: staged photography is art because the artist produces something that he is in total control of. The mere snapping of photographs was always suspect because of its dependency on the environment and on chance. Staged

photography is not contingent, and hence it is considered "real art." More-over, it is highly coded in contrast to regular photography, i.e. it is intentional, predetermined, and readable. This type of photography turned out to be liberating and opened countless possibilities for the future, even if it sometimes mutated into a new kind of luxuriously framed salon painting.

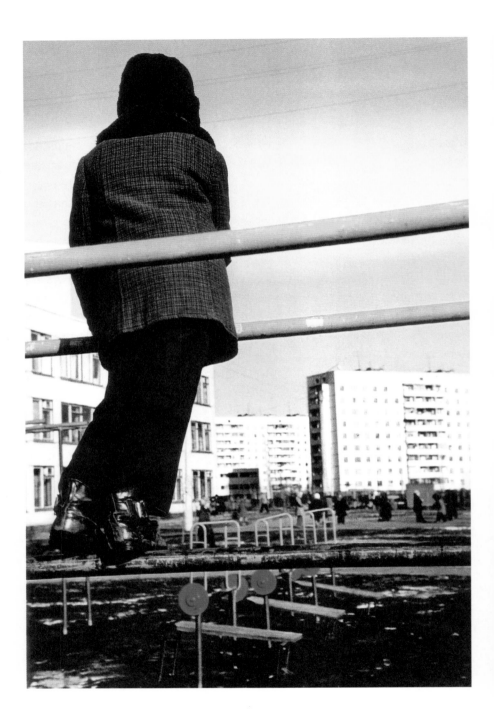

Photojournalism in Crisis

This development radically challenged documentary photography. "Is photo-journalism dead?" *American Photo* asked in its September/October issue in 1996 and addressed a problem that has been the subject of heated controversies for quite some time. So far, one had the impression that the answer was always a stereotypical yes or no, depending on which group gave the answer – the more or less homogenous group of the makers (photographers, photo editors, agencies) or the more heterogeneous group of critics. It even seems that the answer was dependent on two very different language games linked to two very different concepts of how to record the world and of the world to be recorded.

In this issue of *American Photo*, it seemed that the makers were starting to be aware of this crisis, too. It was no longer rejected as a notion of outsiders. A survey among well-known photographers, agencies, and photo editors from all over the globe gave you the impression that photo-journalists belonged to a fragile and assaulted profession. A lot of them believed that some things had to be changed and resolved if photo-journalism wanted to survive and continue to play a role. I will pick out three of these statements:

Magnum photographer Luc Delahaye stated that "photography is play-ing a less significant part in today's media. TV with all its various opportu-nities to reach the masses is the leader." Susan Meiselas, the well-known New York-based photojournalist, complained at some more length: "I am pessimistic that new media will seriously support in-depth work. I cannot imagine that the multimedia world will accept photographers as the great story tellers. They just want pictures for their archives and consider us mere purveyors, which particularly hurts me." Robert Pledge, the owner of

Boris Mikhailov, Untitled. From "Red Series," 1968 – 1975. Gift Andreas Züst and Mara Züst

Contact Press Images, concludes that "in its current form photojournalism isn't particularly helpful, as harsh as this may sound. During the past 60 years, from Erich Salomon to the Gulf War, its preferred role was to mean-ingfully inform the public. But these days TV is fulfilling this function, and sometimes does it even quite well. Certain individualists will doubtlessly continue the tradition of photojournalism. But books and exhibitions will be their media. They will produce long-term stories, often grant-supported, that will give us an understanding of the world different from the one we see on TV."

As a whole, these three statements talk about a fourfold crisis of photo-journalism. First, there is a loss of space in magazines (at least for serious photojournalism); second, photojournalists have lost the fight against time since TV can inform people much faster; third, there is a loss of authorship because a lot of magazines and new media are increasingly less interested in the in-depth view of an author; and finally, they are talking about a struc-tural change forcing serious journalists to find new outlets and new backers. These statements are talking about a misery of the circumstances under which photojournalism has to be produced, but they talk much less about a crisis of photojournalism itself, a classic mechanism of displace-ment. The actual crisis might turn out to be that only a few of them (or out-siders from other discourses) question what they are actually doing.

The reporting image, however, is not dead at all, it's just that a shift has occurred. The diminishing role of photography in mainstream maga-zines stands in a conspicuous contrast to its integration into other fields such as advertising, fashion, and art.

Benetton's use of documentary photographs of a water bird covered in oil, a military cemetery studded with candles, a blood-stained T-shirt, a burning car, a newborn child, a dying AIDS patient, or a boat overloaded with refugees are merely the most blatant, because most provocative, examples of the use of documentary photographs in advertising. What is happening here? Advertising effects in terms of market strategy are real, but its messages are fictional. Hence, the trace of the real, the documen-tary image and documentary film footage, are indispensable media for its fictions. In other words, the more brands of washing powder are washing

ever whiter – whiter-than-whiter-than-white as advertising wants us to believe – the more fictitious the message, the more it has to be embedded in the real and anchored in everyday reality. We could call the advertising world a "market of fictions" with "photo-real" and "cine-real" elements, a world full of castles in the air in need of a connection to the real in order to gain attention and to appear credible. Benetton even used the guise of socially committed journalism. On the level of visual language, they acted like Greenpeace in order to appear "real."

Fashion is leaving the catwalk, its exaltation and splendid isolation, its stagy theatricality, delving into the everyday and turning into street fashion. Fashion and documentary photography are starting to resemble one another. The difference between the document of an actual situation and a staged "real" situation is blurred. In this superimposition of documentary elements and fashionable fabrication fixed points are dissolving in a mixture of the real and the theatrical. Fashion photography as a fabricated fiction seems real, and the formerly homogenous, contained, and tangible real is refracted into hybrids perpetually reproducing and redefining themselves: fashion becomes a "bazaar of realities" with many colorful and gaudy textile components.

The entry of photography in art as a sign of the real has been described above. In contrast to the disappearance of photojournalism in its traditional field, representations of the "real" are entering various areas of life as mere particles, as a guarantee of presence, as a guiding post in the midst of uncertainty. In earlier times, this function was fulfilled by the relic, the mortal remains, which have now been replaced by the photographic document performing the function of the "reliquia," tangible remnants of a fleeting and changing reality.

We are dealing with a paradoxical movement. In its traditional professional field photojournalism is disappearing, whereas in other fields, such as fashion, advertising, art, in image banks, and in the documentation of our own private daily life, we are confronted with an increasing accumulation of documentary photographs purveying particles of the real, evidence of our hunger for the real, however mediated it might be. Upon closer inspection, these developments are only apparently contrary

and incompatible since we are looking at different types of photography that have to fulfill different types of expectations. Serious documentary photography is about investigating the world. It attempts to generate and communicate content by photographic means. Advertising and fashion love to use the rough appearance of this type of photography, but not as a serious investigation of an issue. They use it as a mere Baudrillardian shell, a decorative wrapping paper. It's not about content, but the mere semblance of it, an attractive rustling of the real. Douglas Crimp talks about the transition from "information" to "expressive style," Rosalind Krauss calls it the shift from the "view of the world" to the aesthetic concept of the "landscape." The landscape of reality is woven into advertising, just like you season a dish or spray a scent in the air. A mere whiff of the real.

The constant friction of photojournalism and magazines, allied forever in friendship and enmity, has been intensified by this development. First, on the pragmatic everyday level of production. Photographs are shown the wrong way round or an upright format is tilted. A caption slyly manipulates the "reading" of an image. Photographs and ads start to ironically or cynically comment upon each other because of their inept placement. Photographs are digitally distorted, elongated, or compressed. All of these accidental or intentional blunders, testifying to the precedence of design over image, challenge the idea of the photographer as author. The exaltation of authorship and its insistence on the simple, unadorned reproduction of an image, however, often prevents an exciting and dense intertwining of text, photography, and design. The black borders of many documentary photographs are not only proof that the photographer was actually there, took a picture, and enlarged it without modifications; they should also protect the photographs from interventions on the part of the photo editor or the graphic designer.

A second aspect is the friction of photojournalism and magazines on the level of structure and content. The perpetual fight for attention and

Christer Strömholm, Place Blanches (Vanda), 1960s

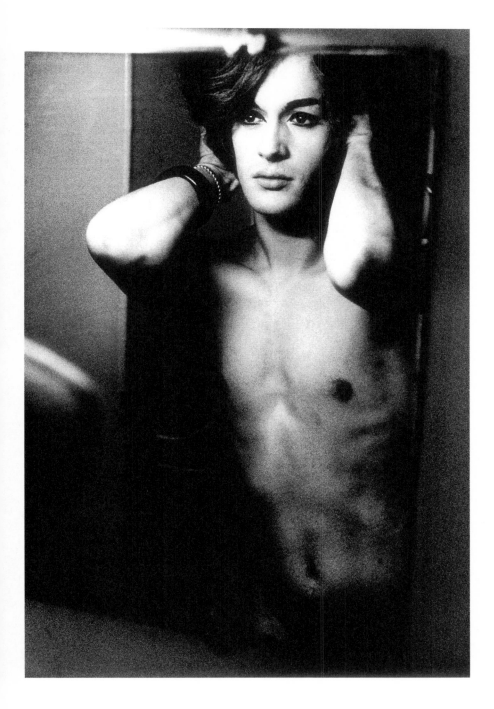

market shares, the internal fight between editors and advertising managers, and the demand to keep up with the rhythm of MTV and CNN, the fast-paced editing of video clips, has completely changed the structure of documentary photo stories. There is hardly any space left for a narrative or a complex arrangement of images. In the 1970s and 1980s, photography was forced to increase its visual impact and its sheer size. Two or three double-page photographs, together with the title, set a story in motion, followed by a short illustrative text – and the article is ready. Its message should be immediate, forceful, up-close, and instantly readable.

That's the fate of images in magazines. The photographs had to become closer, more direct, and as easily understandable as advertising's message on the opposite page. In the context of the media's armament in the war for market shares, they had to be as shocking as possible. Shockingly close to the event, to the front, to the wound, to sex and death. In the 1990s, the emerging infotainment relied not so much on shock tactics, but on the attractive, surprising, and entertaining visual event. Everything has to be an event, i.e. subject matter and images must not be too serious or too gruesome, but neither are they allowed to be too careful or too contemplative. This is the current framework for what used to be called "photojournalism."

But photography and magazines are also fighting with each other for financial and ideological reasons. Magazines are increasingly less willing to fund stories requiring costly research. Cutting costs is certainly one reason, but there is also an ideological aspect. Many magazines no longer desire an in-depth perspective. Increasingly, like in fashion and advertising, a mere whiff of subject matter should be enough. It's not the "thing itself" in all of its difficulty, complexity, and consequences that matters. It's the mere flavor of Afghanistan, Kenya, Kurdistan, Zaire, or the Lebanon they desire. They are not interested in information and an in-depth look at a situation or conflict, just the look of it. Three days here, three days there, most of the images are set-up shots, posed and staged portraits – and that's it. In *American Photo*, New York-based photographer Harry Benson called this type of photojournalism "the *ValuJet* of photojournalism – stuck in the mud," referring to the crash of a *ValuJet* airplane in the swamps of Florida.

This development has several consequences. There is a trend towards two different types of photojournalism. Entertainment-industry photojournalism – event photography, feature photography, or illustrative photography – continues to function within the existing framework and is well paid in comparison to the work involved. In a strict sense, however, it cannot be considered journalism. It belongs more to the category of "attractive photographic page adornment." Serious photojournalism, carefully researched, time-consuming, and labor-intensive series of images, has to find new ways. We have to find new models of funding and new types of publishing them.

Photojournalism today is in danger of being eliminated, if it does not face some basic questions. What does and should photojournalism still show us? Haven't we seen everything? What kind of photojournalism do we need? And do we *really* need it? What is our idea of a photojournalist today? And in which media will they feature their work? And are we as viewers satisfied with photojournalism? Are we interested in the viewpoint it represents? Are its images relevant to our age and its problems, or are they in danger of looking at complex circumstances from a "false" point of view, disregarding the impossibility of representation?

Questioning the concept of the "author." The growing importance of "authorship" in photojournalism was certainly justified for a while and in several respects, in particular with regard to the publishing industry and its standards. In terms of content, however, we have to make a few objections. When the Kunsthaus Zürich showed a large-scale Magnum retrospective in 1990, Niklaus Flüeler reviewed it in the newspaper *Weltwoche* under the headline "No photography is greater than Magnum." At the end of the article he described in almost hymn-like words how the photographer goes to the limits of his psychological and physical capacities to bring home images of joy and sorrow in the world. "To document these realities without artifice and gloss, but with supreme mastery of the craft, while remaining stoic at the limits of the physically and psychologically bearable – this is ultimately only accomplished by a type of photography that Magnum might not have invented, but certainly carried to an almost

absolute perfection. Time and again, it achieved the almost incredible: capturing the decisive moment – man in his/her beauty and mortality, at beginning of life, at apex of power or of an age, at end of his/her days – in a single, unforgettable image of incredible or horrifying but always over-whelming beauty."

It is one of countless examples demonstrating how the visual author is stylized as modern-day hero or stylizes him/herself as such. The will to endure pain and to face the world's horrors, fearlessness, personal commitment – these characteristics, together with a mastery of craft, are redefined and stylized as criteria defining the image's truth value. With a little bit of malice, one could even say that life "on the road," combined with a lust for adventure and the male cult of the lone wolf, the desire to be a solitary observer in the desert or at the front, are covertly redefined as measurements of the truth, accuracy, and moral rectitude of a photo doc-umentary. The author's psychological predisposition becomes a touch-stone of truth and authenticity.

During the past thirty years, however, science and art have aspired to the exact opposite. They have de-personalized the point of view, under-lined its relative character, and tried to show a situation from as many viewpoints as possible – based on the insight that a singular point of view is not going very far in an ever more complex and interconnected world; where nothing is what it appears to be. The personal point of view is always reminiscent of the notes of solitary *flaneur* in the city, in this case dis-guised as a socially committed observer. But life in a world over-deter-mined by various media requires other concepts of observation.

Questioning the image of the world. Do we consequently need photo-journalists who may not change their attitude but are able to change their vantage points at will? Photographers in command of a whole range of ways of looking at the world – whether it is the scientist's detached, objective gaze, dissecting things and examining situations, or whether it is perspec-tive of the committed and compassionate observer taking ravishingly per-sonal and movingly intimate images? Aren't we in need of photographers constantly searching for the approach appropriate to a specific situation?

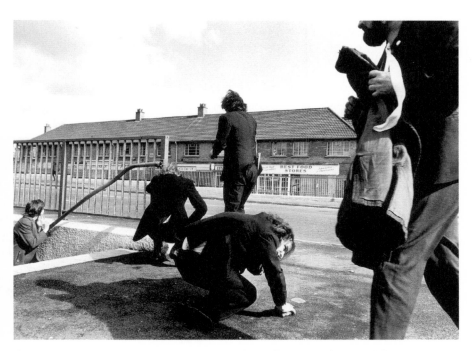

Gilles Peress, Untitled, 1972. From "Power in the Blood (The North of Ireland)." On permanent loan from Volkart Foundation

Photographers who reflect their own position while representing the various positions they are confronted with? Photographers who can switch from the close-up view to the view from afar, from a personal filter to a generalizing panoramic view? Photographers aware of the complexity of the world and of its various contexts? Photographers who can think conceptually and develop new visual languages that could adequately represent the world today? Photographers who know that every representation of the world creates it anew for reality is not a stable fact but something we constantly create and change by means of our actions, including our representations of it? Photographers who are not in denial of authorship, but have a different, more open and varied (and hence more contemporary) understanding of authorship in a complex, highly mediated environment. Are we

maybe not so much in need of authors but of operators who know what to focus on in order to represent something as a readable event?

Questions of style and attitude. It seems that photojournalism remains unfazed by the paradigmatic changes in the understanding of the image and the world. Apparently, it remains addicted to various outdated lofty and heroic formulas and unaware of radical change. They still believe, for example, that they can track down the truth of the real by means of a photograph without realizing that truth has become functional and in-visible. They do not understand that in media society even images with an honest intention merely function as non-stop entertainment, as an alibi and opiate, or even as an instrument of supervision and control. Photo-journalism is more or less the only genre in today's media that still insists on the world's truth. They don't not realize that the new ways of thinking and representation that have developed since conceptual art are offering unique opportunities. They still believe that a critical examination of the truths engendered by image-making itself is not pertinent to photography and merely artsy.

The media's arms race simultaneously led to an over-saturation of the viewer. The ever newer, ever closer, ever more horrifying images have be-come redundant. We are familiar with them. Who is still moved by images of starving children, sick Africans, firing soldiers, and workers on strike? As close, immediate, and penetrating the images may be, we have become immune to their entreaties. On the other hand, as a character in a story by Ingeborg Bachmann complains, "Do you believe that you need to photog-raph the destroyed villages and the dead bodies to make me imagine war? Or these Indian children, so I will know what hunger is? What kind of stupid presumption is this … You don't look at the dead to stimulate your convictions."

Photojournalism at large is suffering from stylistic and intellectual exhaustion. The photographs are only too confident of what a good doc-umentary photograph is. Consequently, photojournalism has become aca-demic. It is their home-made crisis complemented by a crisis of circum-stances. And yet, we need their images as we still have to rely on the

visible. Visual narration, despite all the new uncertainties, remains a feasible form of understanding and documenting the world. But photojournalism will only survive if it becomes radically subjective, radically daring and distanced, or radically ambiguous. It has to give up petrified attitudes and must become as agile as a cursor.

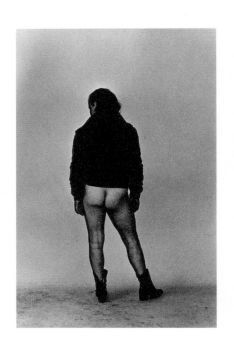
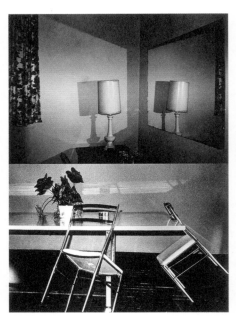
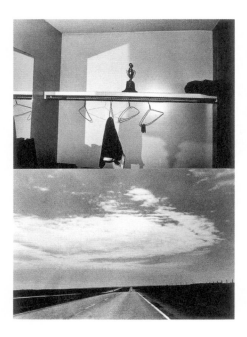
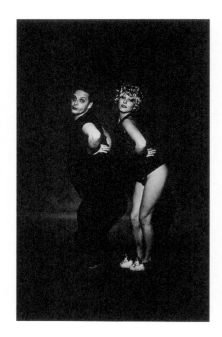

One Museum, Many Types of Photography

Maybe this variety of approaches, views and uses of photography is precisely the answer to the question why we founded a museum for photography. If art museums are starting to evince a great interest in photography, as it is fashionable everywhere these days, they focus on just one percent of the current and past production of photography. They are only interested in photography within the framework of an art discourse. They may prefer this or that artist's photographic position, or this or that expression of an attitude by means of a photograph or video print, and reject the other 99 percent of photography in an act of deliberate delimitation. In an art context, no one asks why photographs of factory buildings are always so bright and clean. This is understandable. But outside this framework it remains an interesting question.

This was the starting point for our decision to found a museum for photography. We cannot meet every expectation, but we focus on the two central uses of photography: on photography as art form, as a means of artistic expression, as the vision of an author, and on photography as an accompanying creative and productive document of social and cultural realities. I am also talking about the countless photographs commissioned for the most various reasons by the industry, the service sector, advertising, fashion, newspapers, historical preservation societies, and science. These fields of photography, in contrast to the visual world considered worth collecting, is a kind of shadow world of our civilization. It is lying around everywhere, in archives, on attics, in basements, and it is always the first thing to be coldly thrown away because of a lack of space, a financial crisis, or restructuring. However, they are a very important part of our

Urs Lüthi, Untitled, 1977. From "Somewhere on the Road We Left the Time behind Us, America 1977." Gift Rudolf Koella

visual memory and have influenced our ways of perceiving the world more than any creative photography for we encounter them entirely unprepared every day and everywhere.

The tension between photography as a fine art and photography as an applied art, the crossover of independent art work and commissioned work strongly determined by social and cultural norms, can stimulate a very fertile interaction. Establishing a space for this kind of fertile interaction is the goal we have pursued during the past ten years. Sometimes it is an art space, sometimes it is a space dedicated to cultural history and sociology, and sometimes it is a classic museum for photography. It's *one* space for changing kinds of exhibitions and photographs. I believe that this concept is Fotomuseum's virtue. This position in between makes it exciting and offers possibilities that are not open to other places with a rigidly defined framework where "the medium is the message," just like in mass media.

Photography in a museum means showing one medium in another medium. Sometimes photographs are intended for a museum space (art photography for example). And sometimes quite the contrary is the case (in photojournalism for example). Imagine industrial photography suddenly transplanted into the white cube, on the pure, vestal walls of a museum. Showing photography in a museum entails a number of problems. It is an integral part of the art work, if it was conceived for this purpose, if the blank spaces, the frames, and their rhythm were taken into consideration. In this case, the works and their arrangement can be read as a scored performance.

It is quite different for photographs that were not created with the museum in mind. Newspaper photographs are usually integrated in the dense layout of a newspaper and work within this context. Once you hang them on the open, white wall of a museum, they are lost and seem quite helpless. They are created on commission for a certain magazine at a certain point in time and are published within a framework of words (titles, text, and captions). The museum and its demands can easily overwhelm them as they are suddenly in a totally different framework dedicated to exhibiting and celebrating the masterwork and the master print in a classi-

cal sense. Framed and matted, they are shown in a format reminiscent of neither book nor magazine. Arranged in an austere and endless row of single images, quite possibly without any accompanying text, they are all on their own, hingeing solely on their own aesthetic potential. Photojournalism's viewpoint, intention and attitude are displaced and dissolved as context and supporting information disappear.

When a photographic document enters the museum and its totalizing context, whose ultimate purpose basically remains the auratic presence of the art work, the document looses its own context and has to struggle with aesthetic concepts that it does not a priori share. It is always in danger of looking like an example of bad, even ridiculous, taste.

These days the central tenets of museums are changing. We explicitly understand Fotomuseum Winterthur as a "place for the discussion of the medium photography," and much less as a place to ceremonially celebrate "the fine art of photography." It is rather a space for discourses, a space dedicated to "reading," to information, reflection, and critical examination. This context becomes increasingly evident in the sequence of the exhibitions and events. Within this redefined context of the museum, we use the means at our disposal to establish a specific sub-context for specific works under the conditions of "exhibitionality," as Rosalind Krauss called it. Our goal is always the accurate re-presentation of the content and substance of a work, to ensure that it is properly perceived and possibly understood. Not to talk about the accompanying programs intended to situate and position the work in its context.

An open photo museum probably offers the best opportunity for this. Here photography is not subject to the restrictions it often encounters in art museums. It is not hidden and neglected as it often is in other institutions. It won't be thrown away like the grandiose industrial archives of the past thirty, forty years.

Ten years have passed. We keep on working and are about to open up a new chapter in the history of Fotomuseum Winterthur.

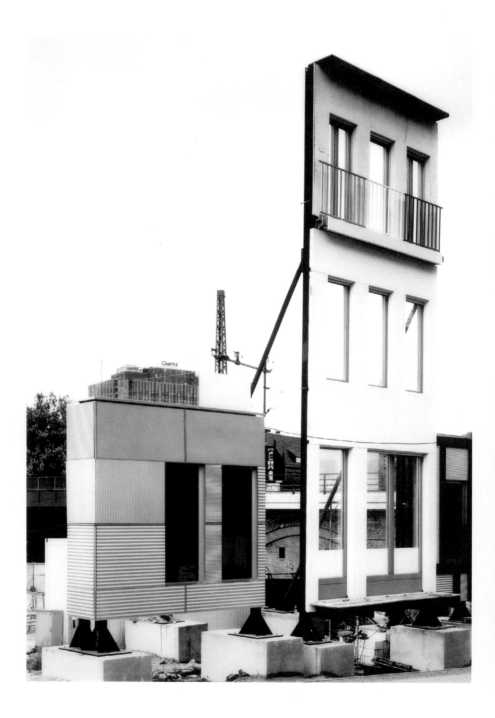

This lecture draws its conclusions from my daily reflections on photography, from reading current literature on photography, and from my writing and talking about photography during the past ten years.

I would like to express my gratitude to all photographers, artists, trustees, members of the board, staff members, members of the Fotomuseum Society, patrons, and sponsors. Together, all of you have made this exciting project possible.

Frank Thiel, City 9/02 (Berlin), 1999. Gift of the artist

This book was published by the Fotomuseum Winterthur on the occasion of the 10th anniversary of Fotomuseum Winterthur.

Edited and translated by Martin Jaeggi
Copy-editing by Maureen Oberli-Turner
Scans, printing by Egli.Kunz & Partner, Glattbrugg

Fotomuseum Winterthur
Grüzenstrasse 44 / 45
CH-8400 Winterthur/Switzerland
e-mail: fotomuseum@fotomuseum.ch
website: www.fotomuseum.ch

Scalo Zurich/Berlin/New York
Head office: Schifflände 32, CH-8001 Zurich/Switzerland,
phone: 41 1 261 0910, fax: 41 1 261 9262
e-mail: publishers@scalo.com
website: www.scalo.com

Distributed in North America by DAP, New York City; in Europe, Africa and Asia by Thames and Hudson, London; in Germany, Austria and Switzerland by Scalo.

ISBN 3-908247-77-2
Printed in Switzerland